# Studies in Mixed Media

Figures and Designs for the Month of August 2013,
by Benjamin Long

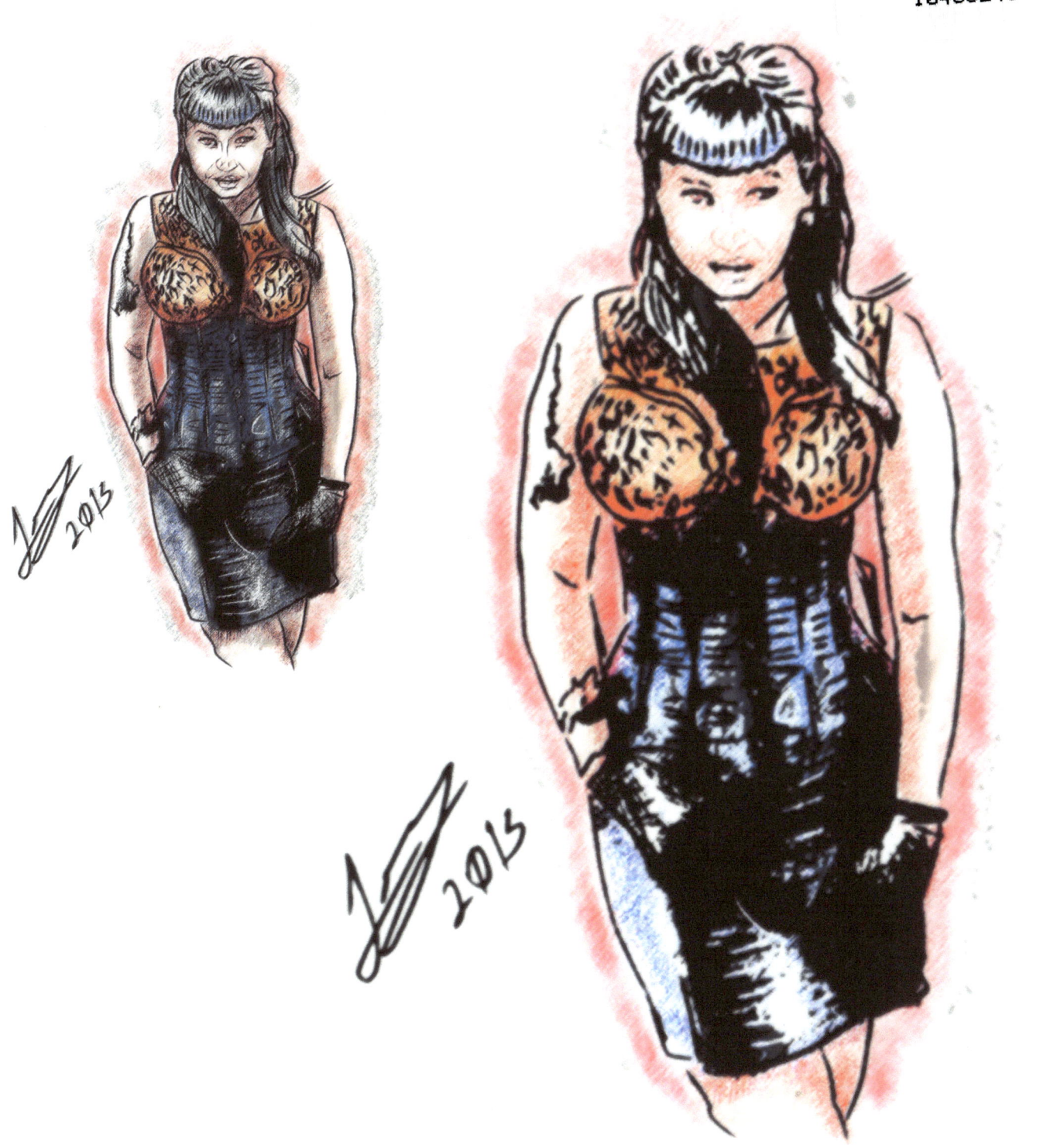

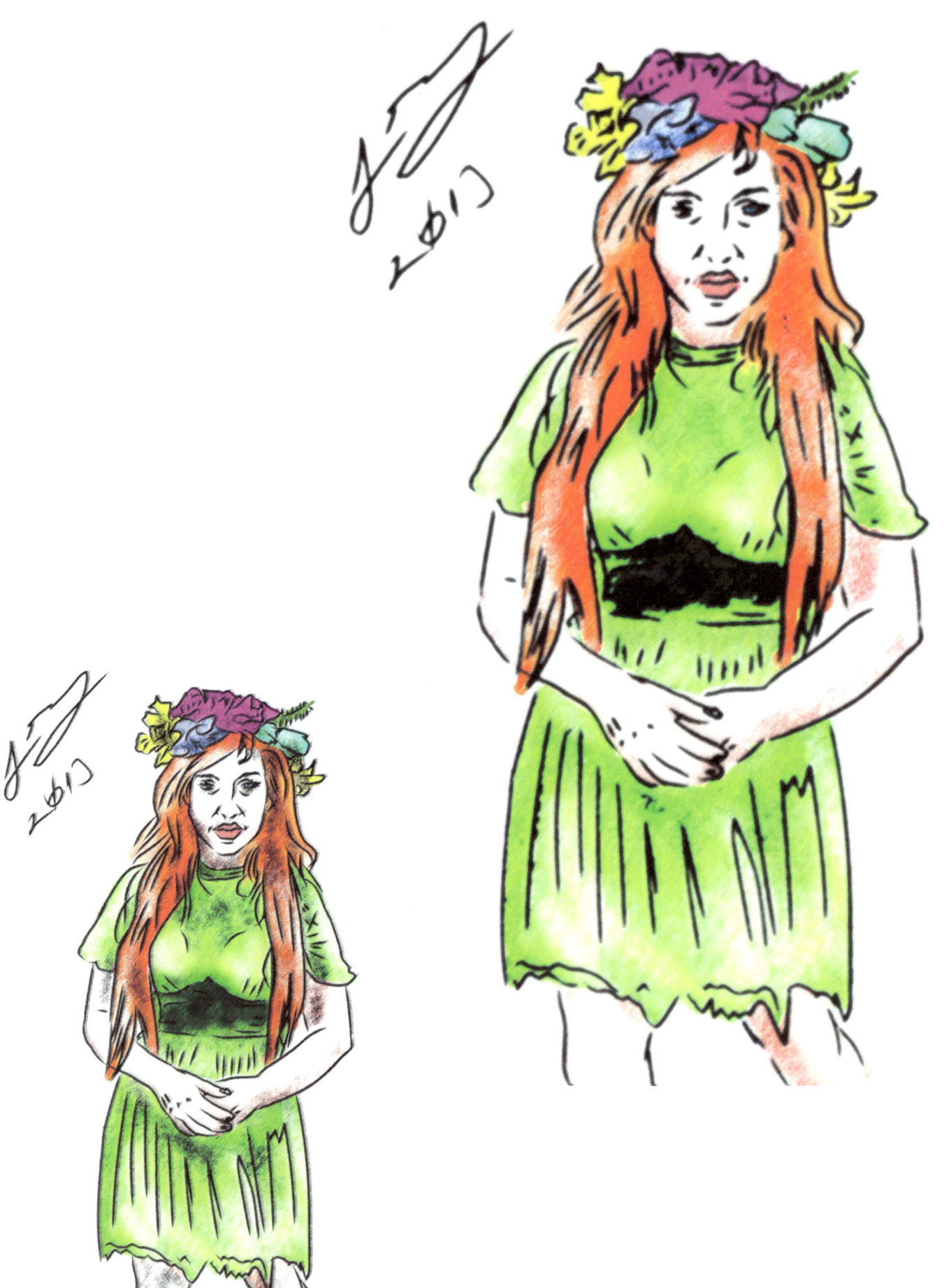

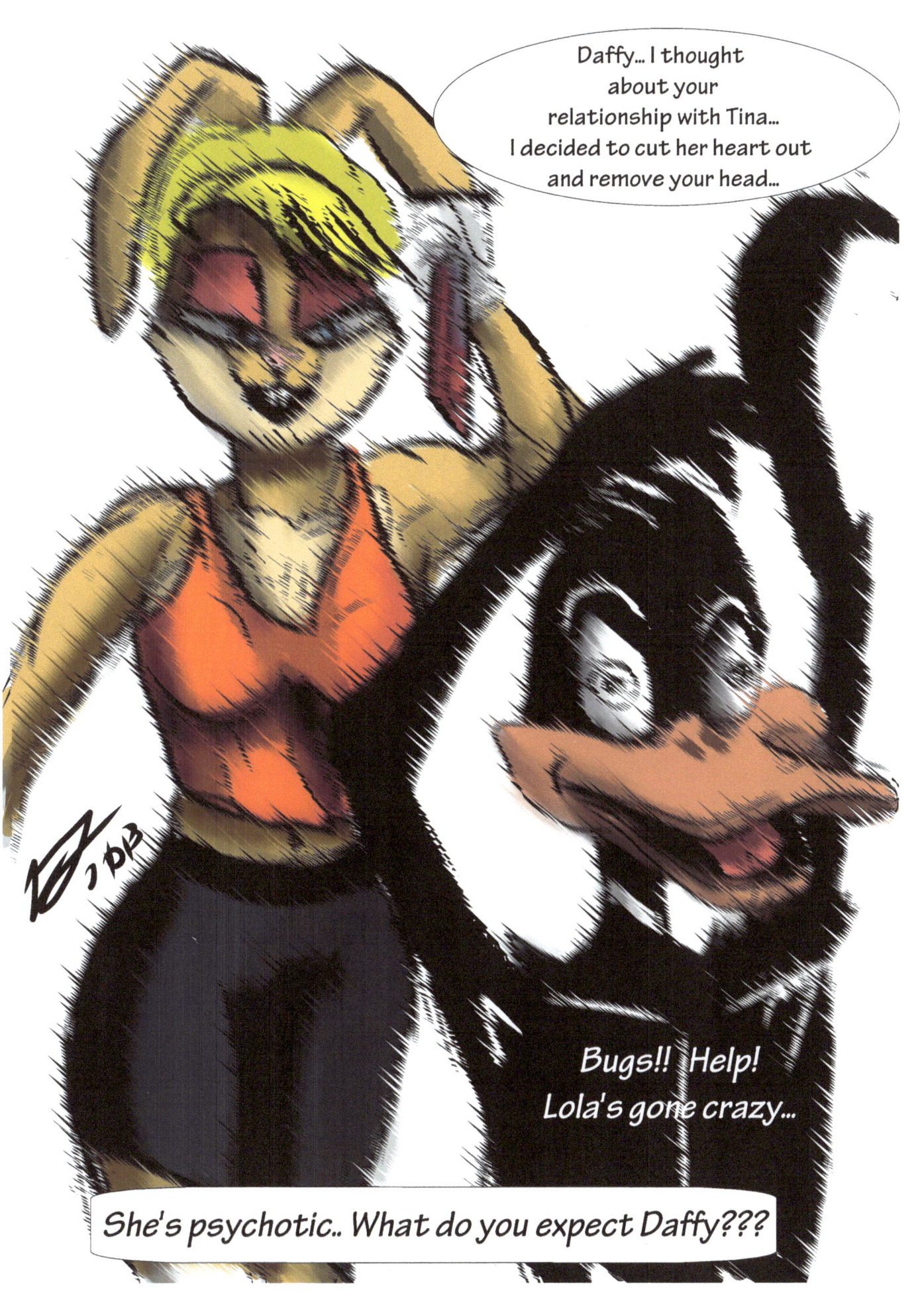

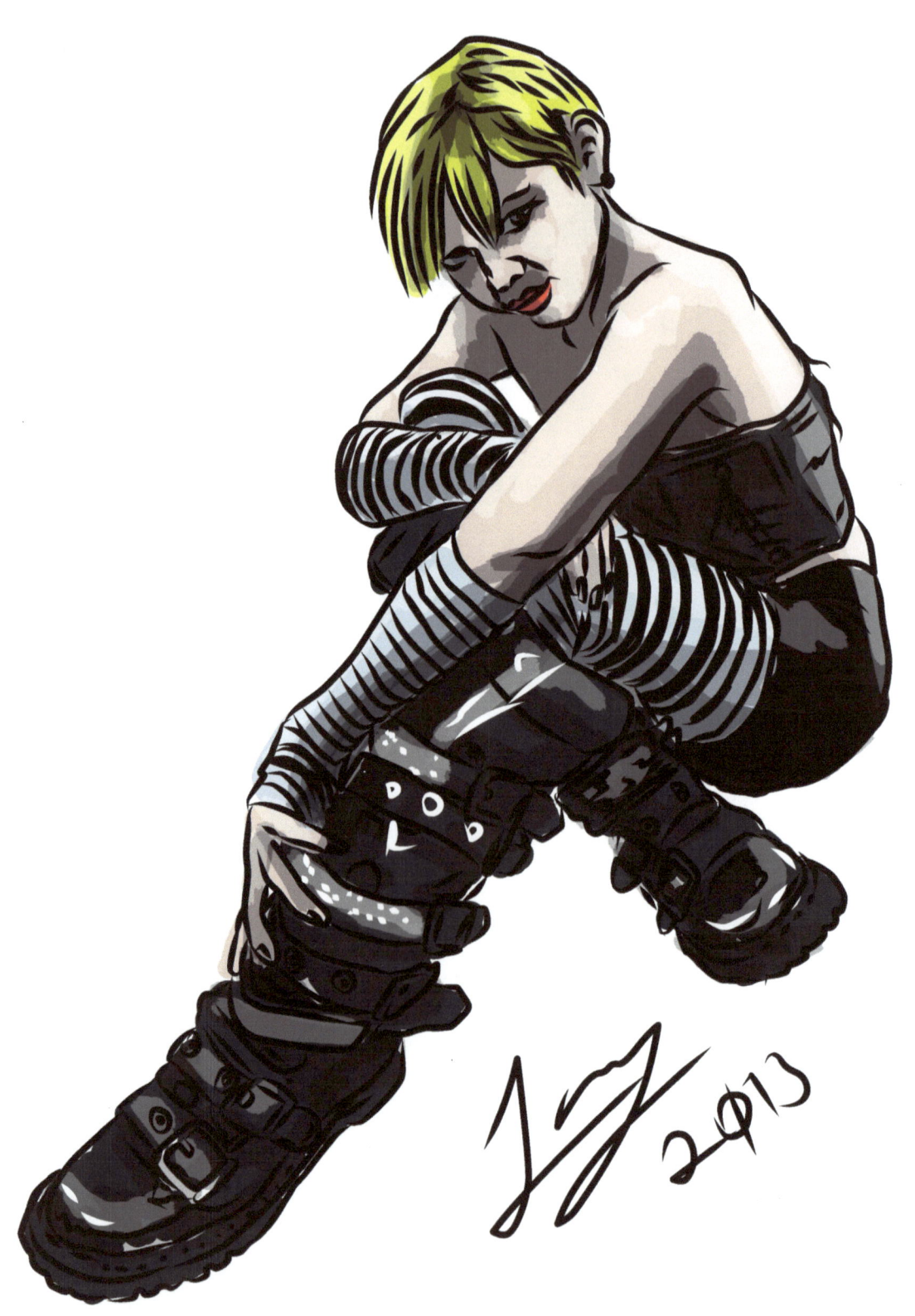

Here is a critique on a drawing of a friend of mine. I redrew the figure to illustrate key technicalities that should be understood. This is a pregnant anthropomorphic character. Despite being partly animal it still has to obey the rules for human form since it is 95% human. You can compare and contrast the diffeences and see how these minor difference can alter the visual quality of the piece.

Right Cheek was too far extended.

Hair was unnatural and lacked contour lines.

Figure's left deltoid was grossly out of proportion in relation to the right

Figure's right shoulder had disproportionate extention in a 3/4 pose the arm appears closer to the body. Make sure the shoulder slopes and is not at 90 degrees...

The stomach is that of a pregnant figure make sure that it flows naturally into the breast and lower ribs. Originally appeared unnatrual.

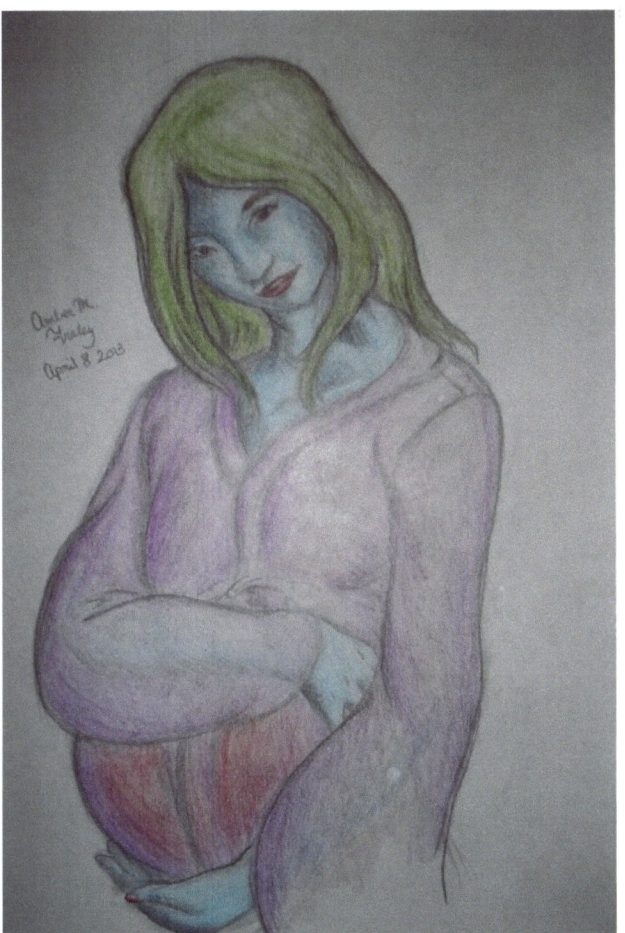

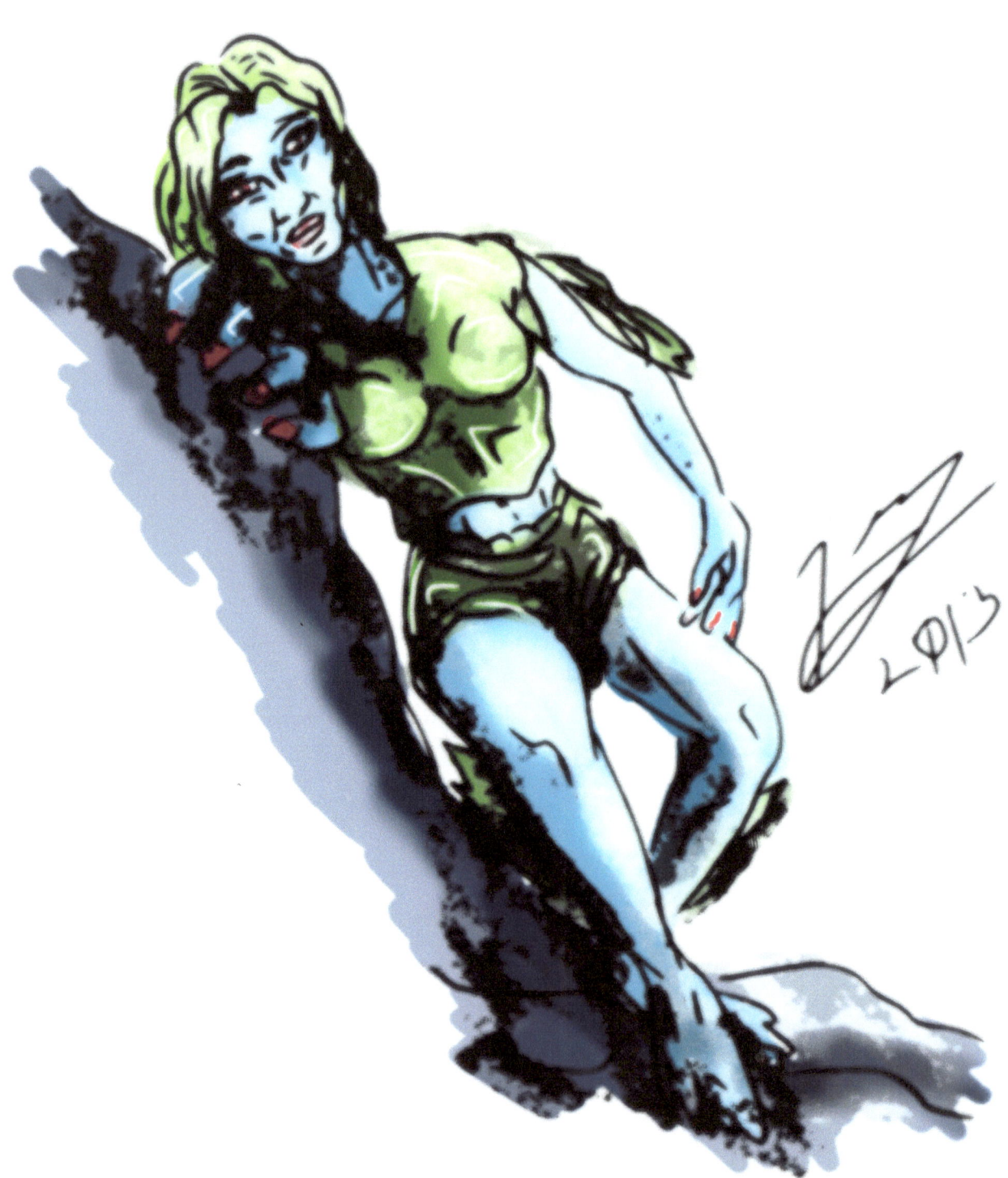

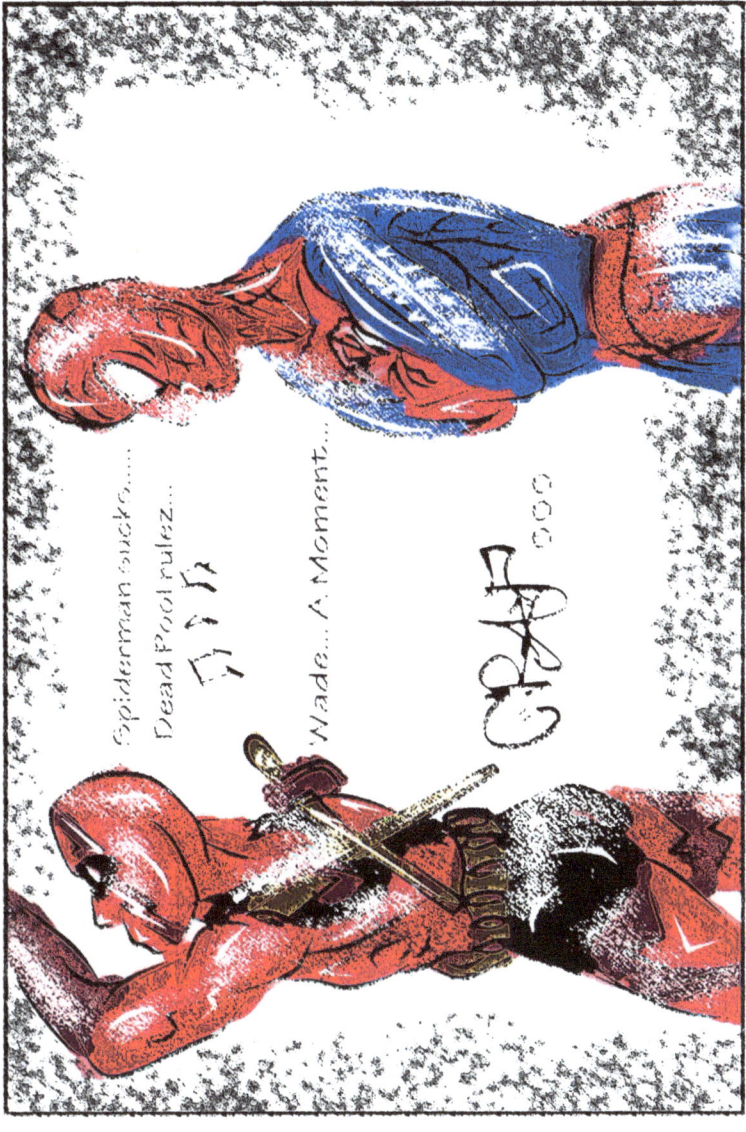

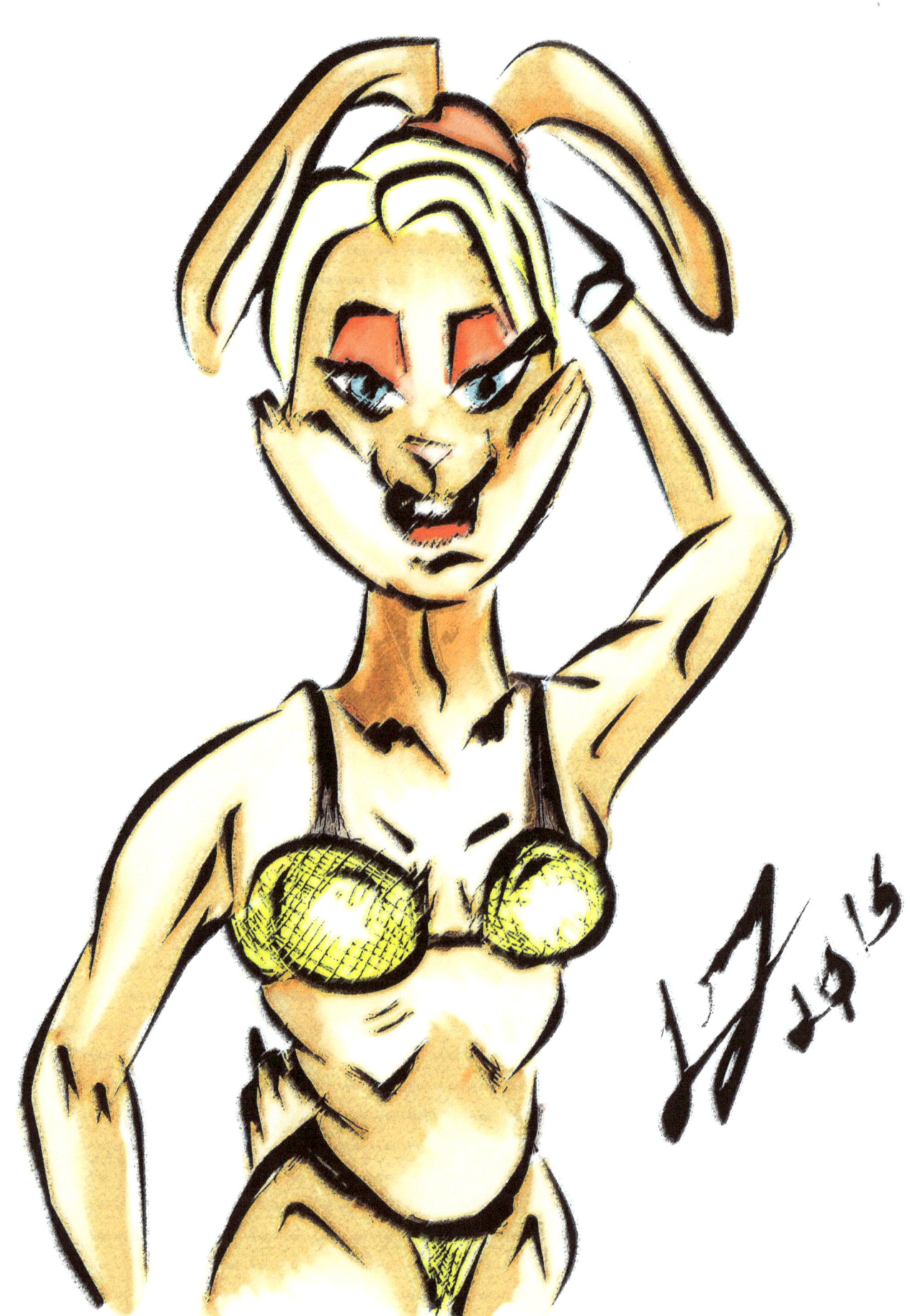

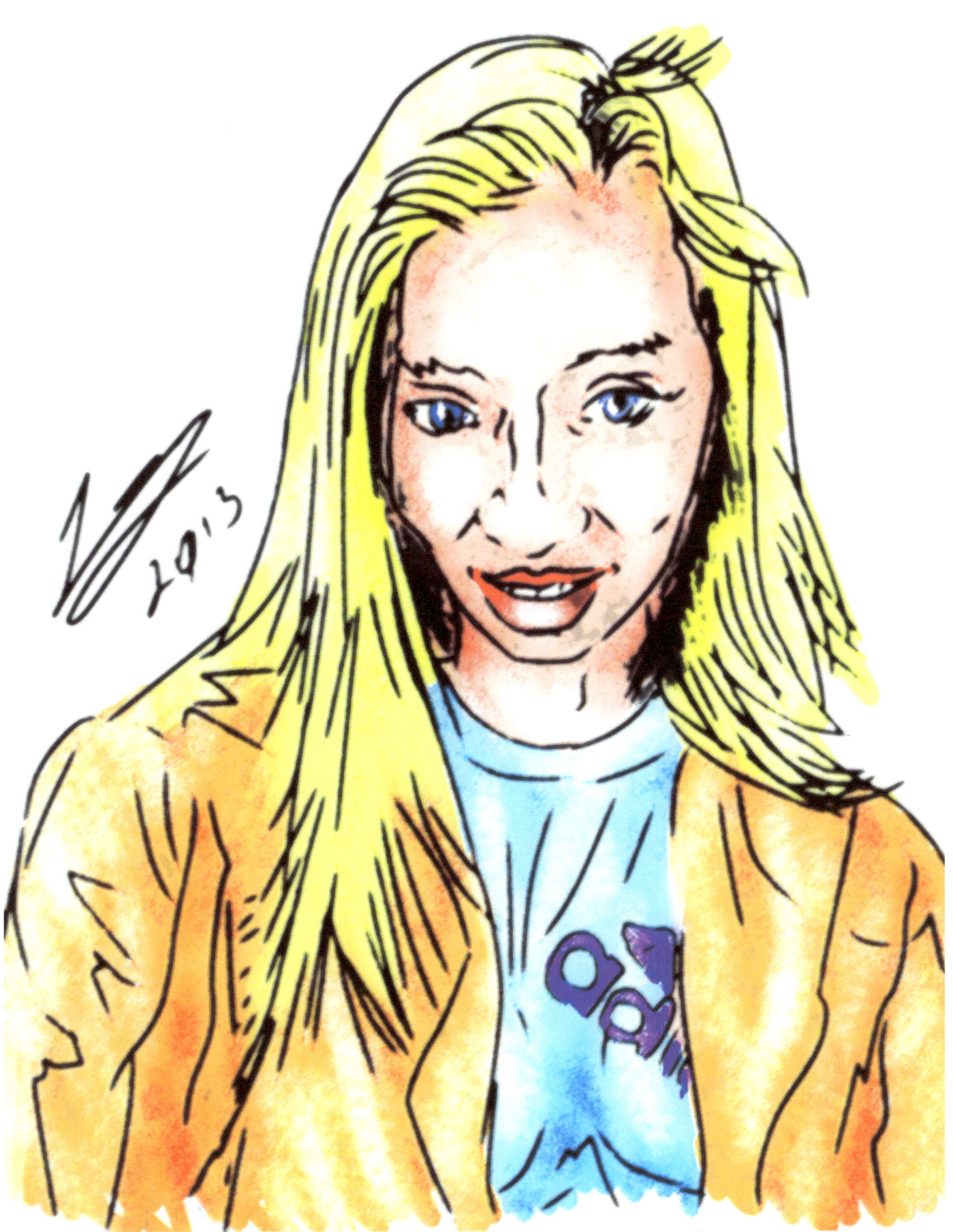

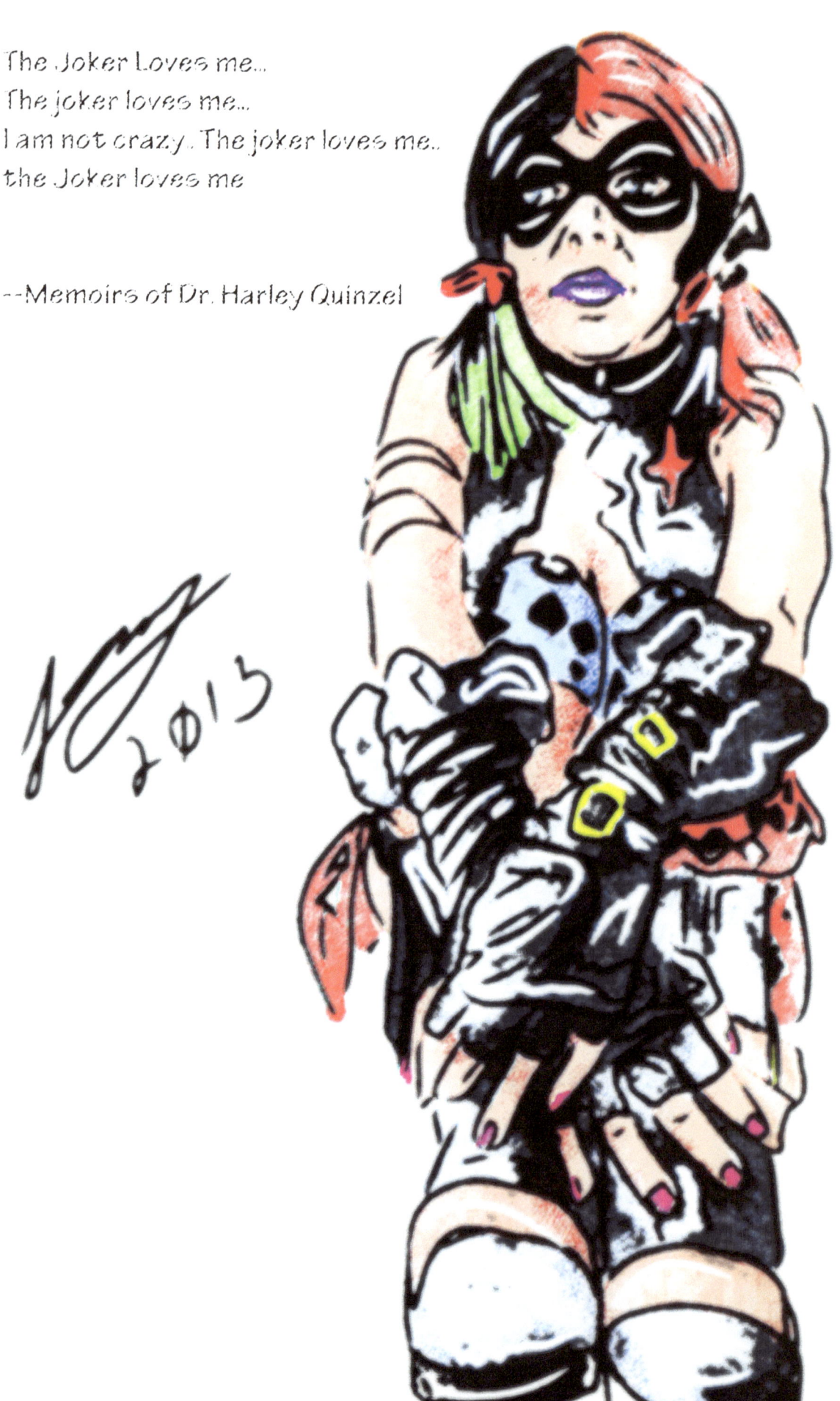

The Joker Loves me...
The joker loves me...
I am not crazy. The joker loves me..
the Joker loves me

--Memoirs of Dr. Harley Quinzel

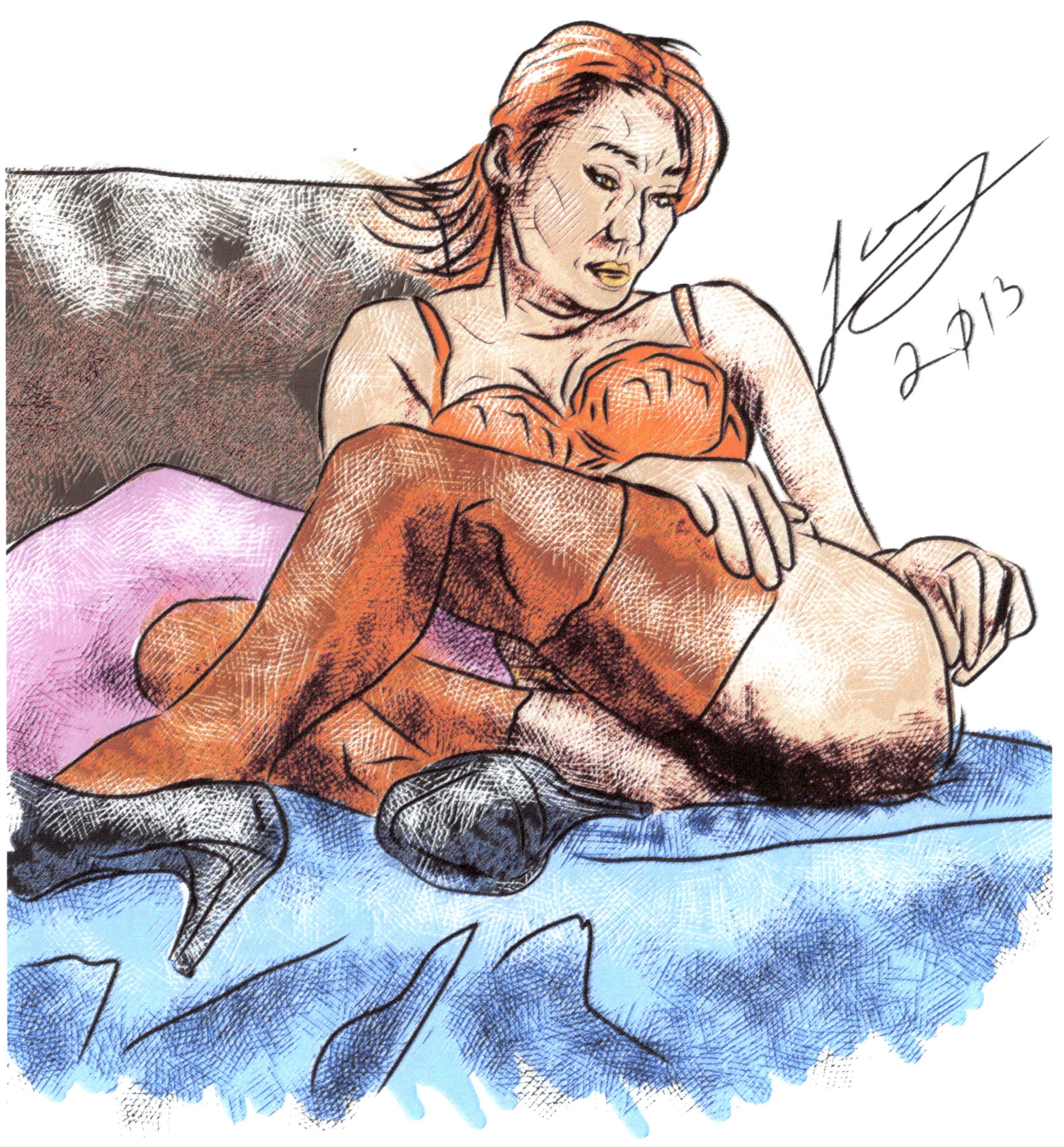

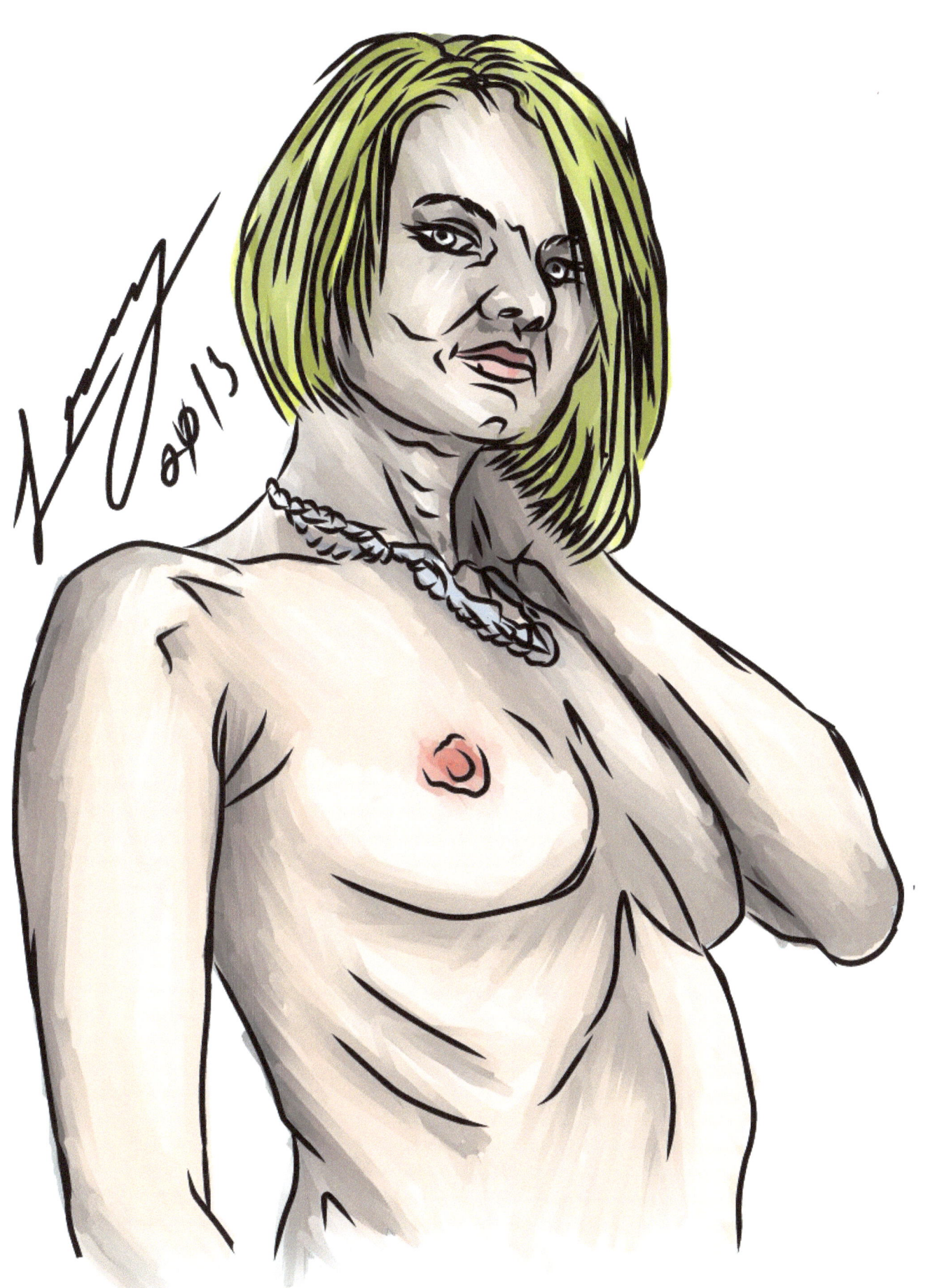

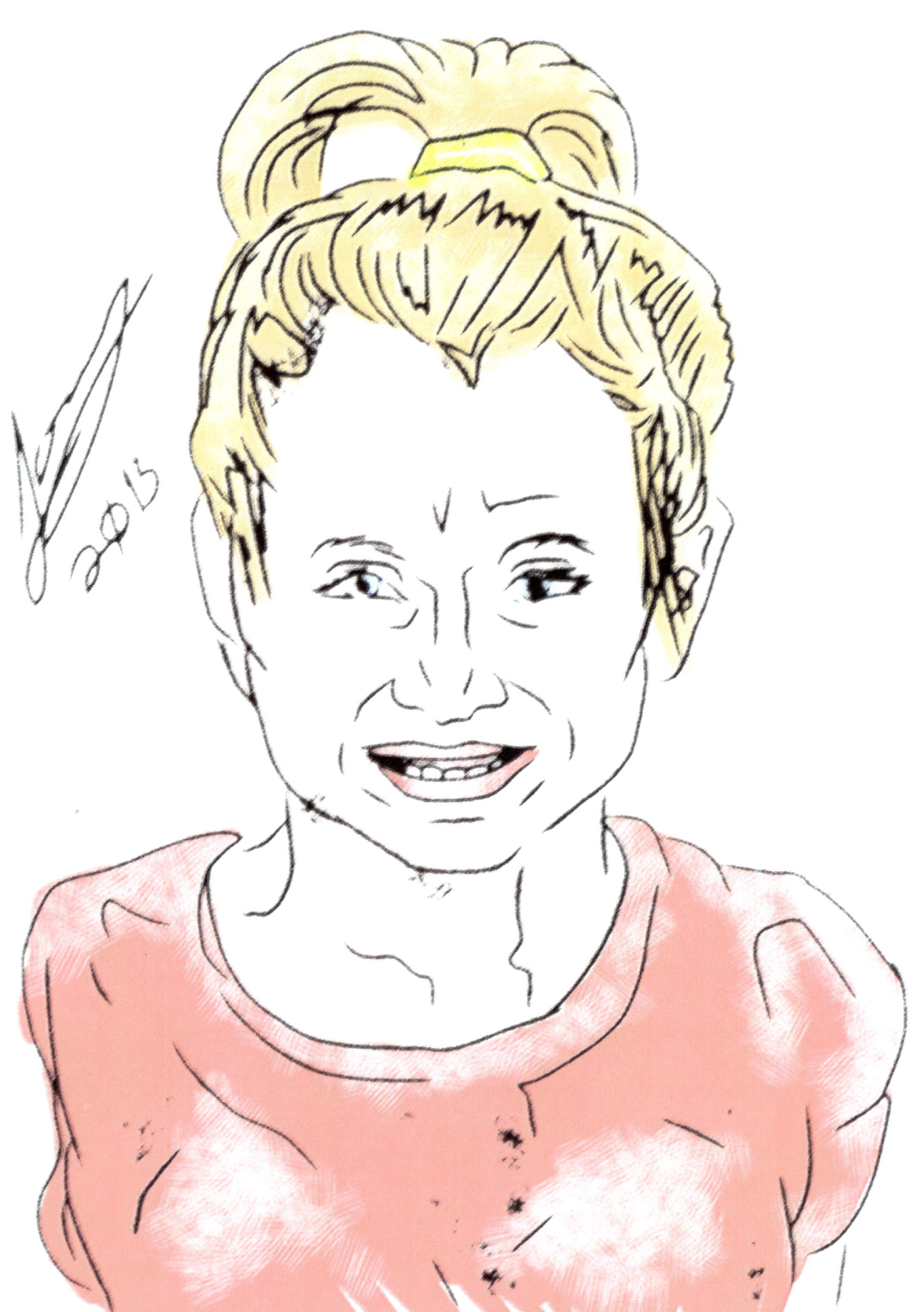

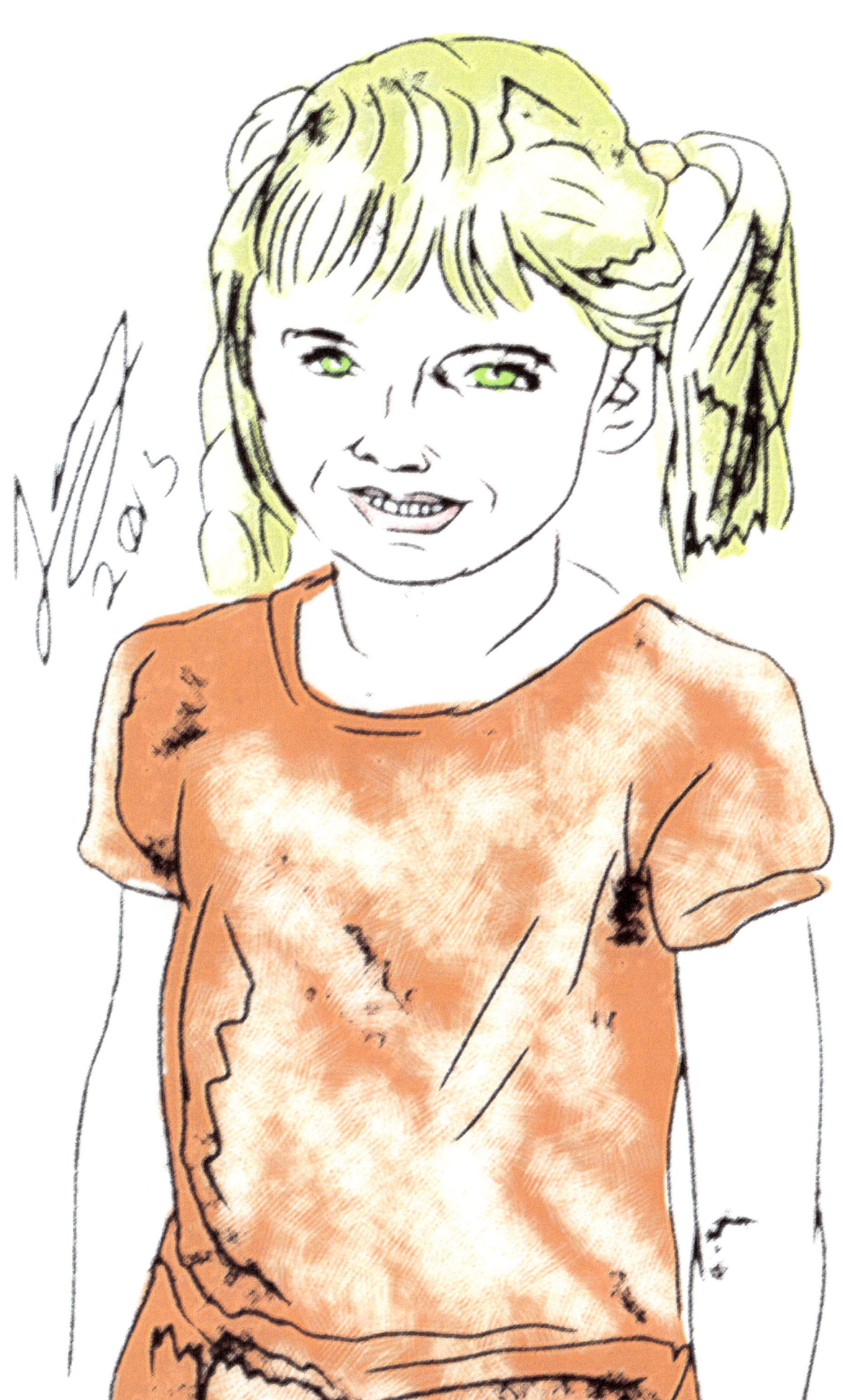

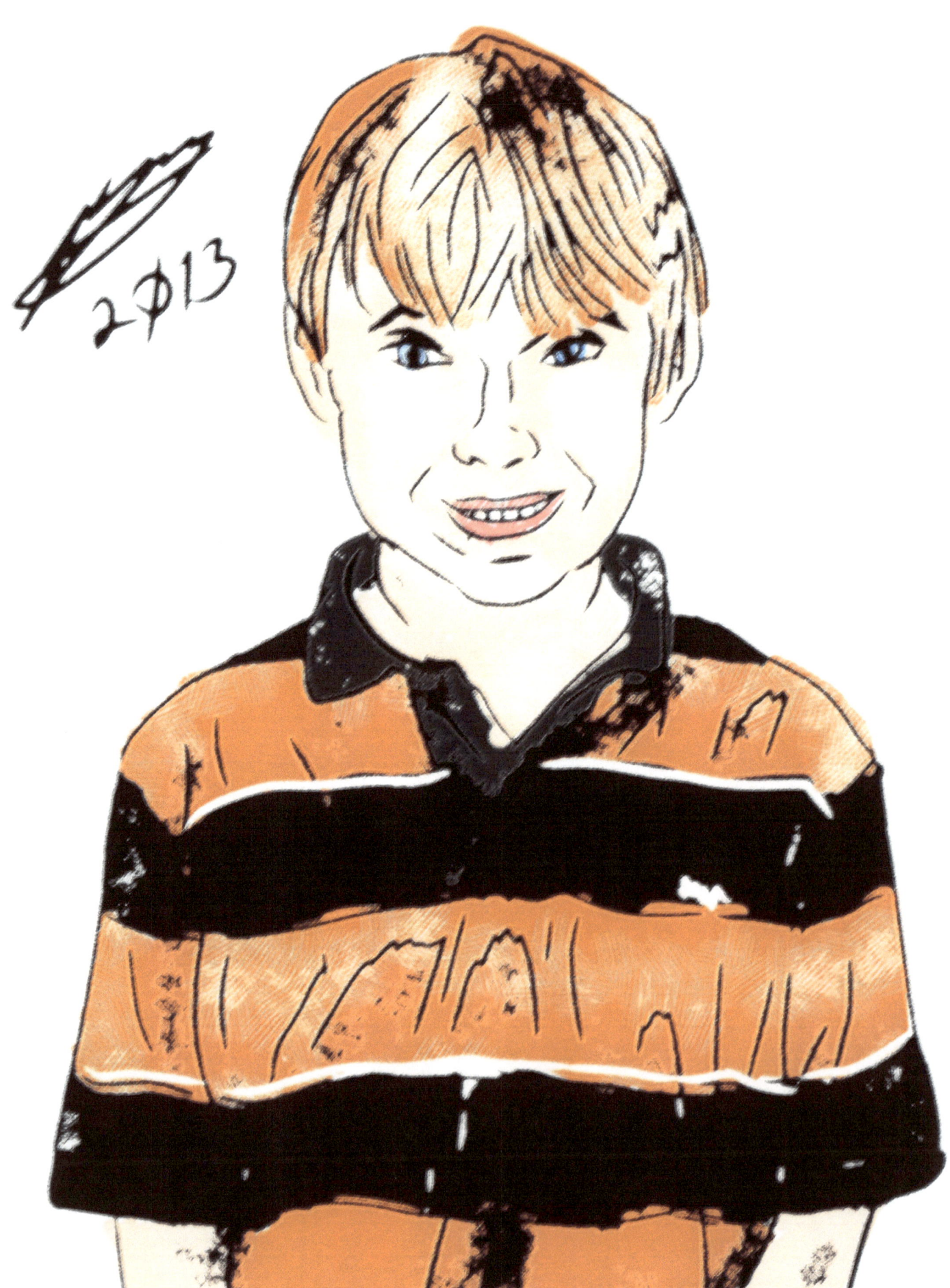

Common Grackle

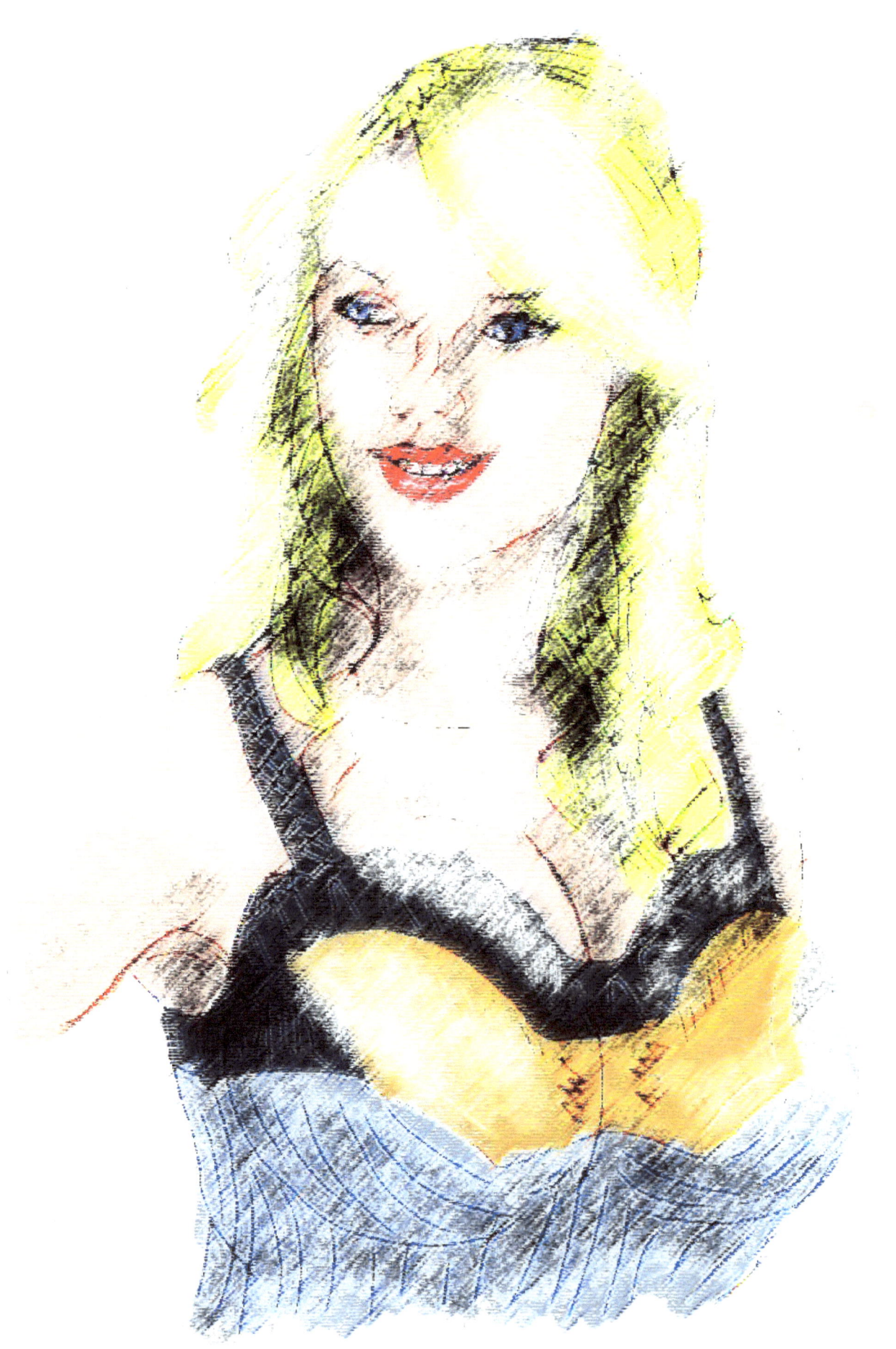

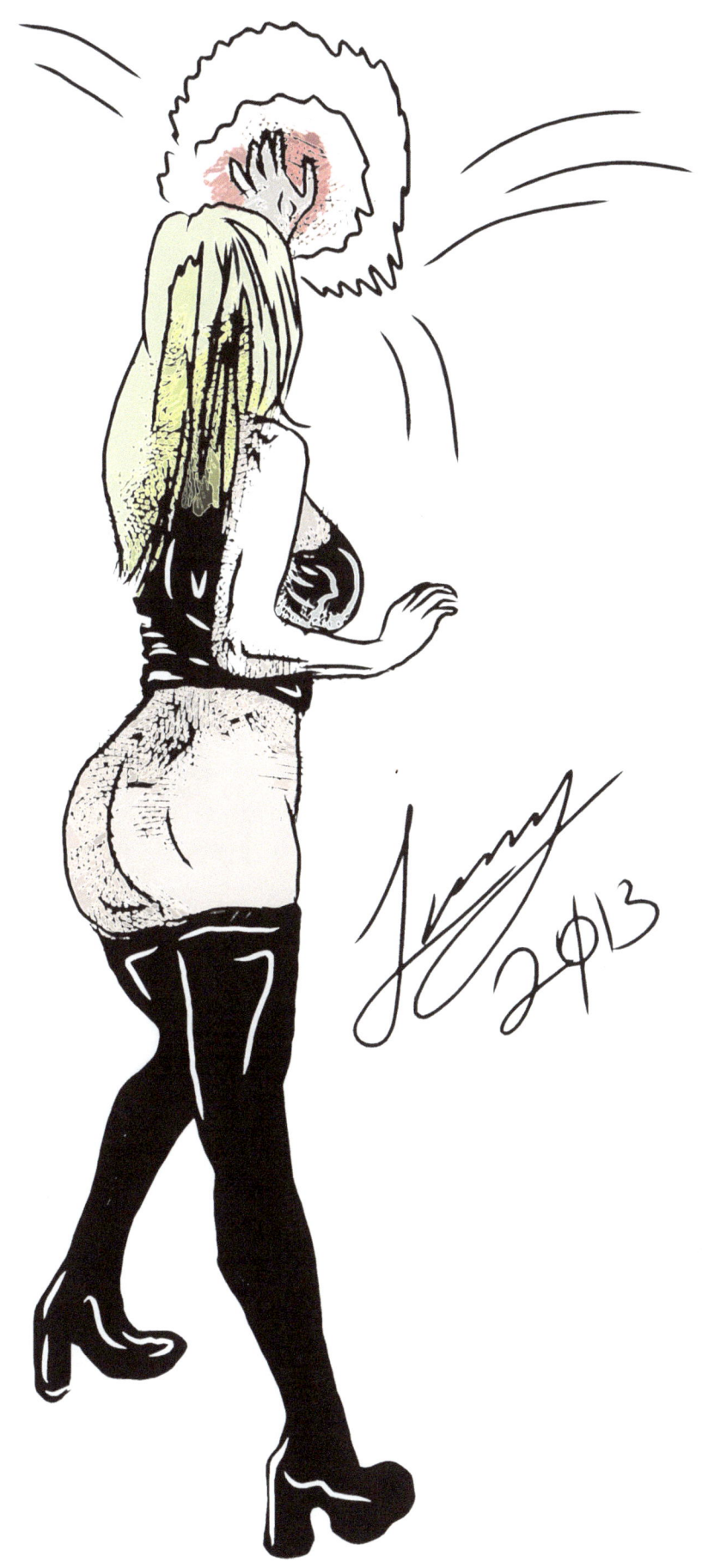

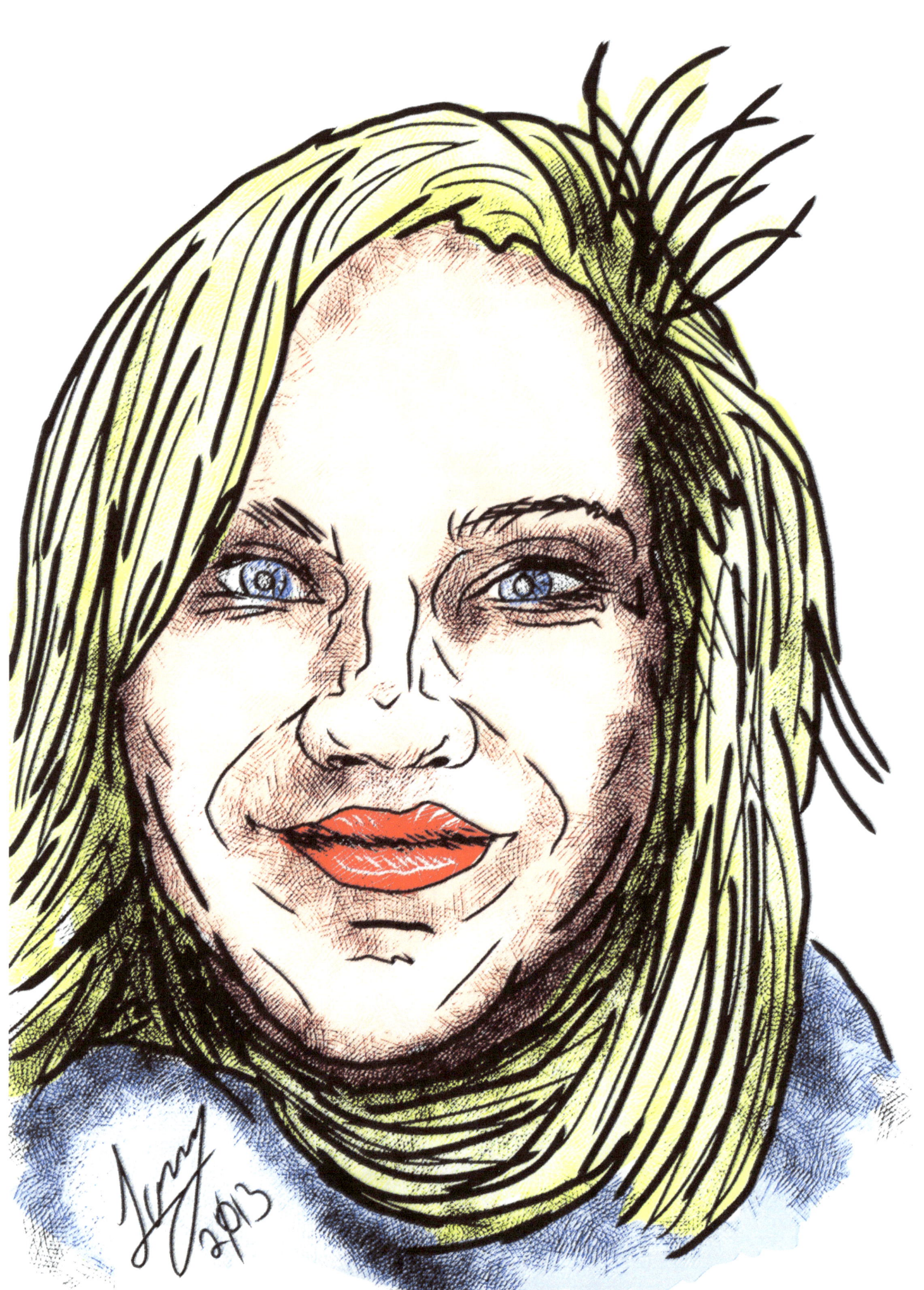

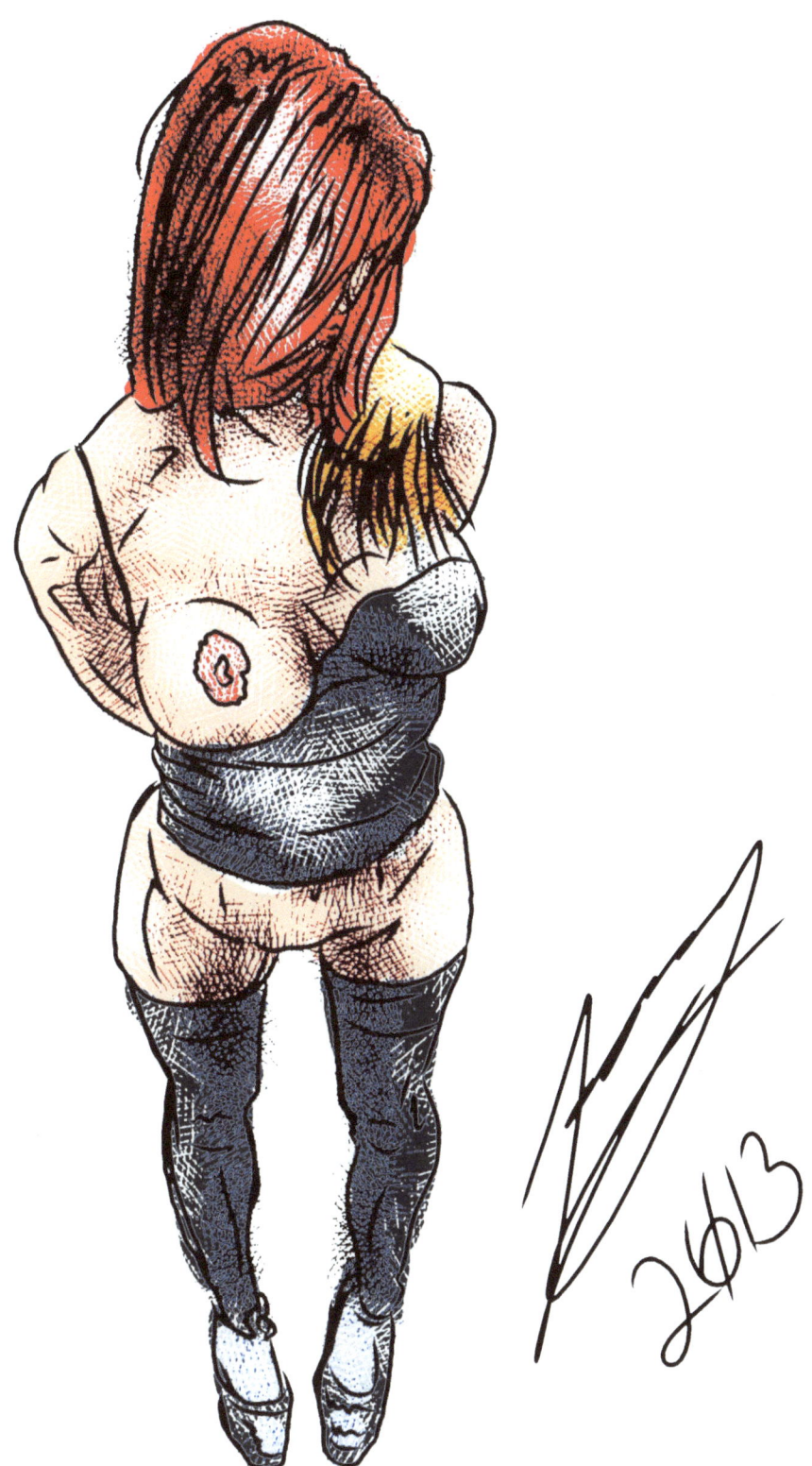

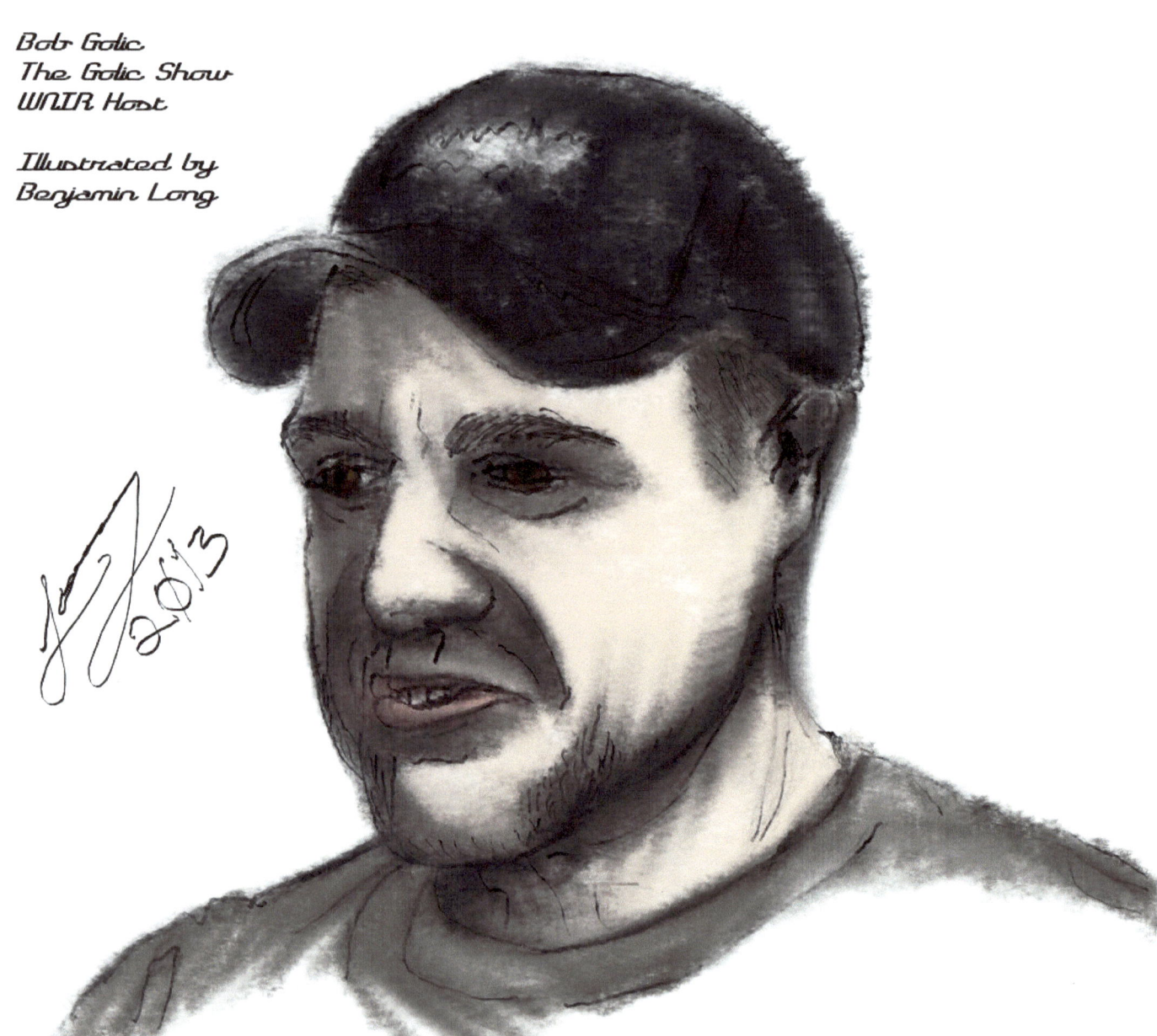

Bob Golic
The Golic Show
WNIR Host

Illustrated by
Benjamin Long

Howie Chisek
RIP-WNIR Host

Illustrated by Benjamin Long

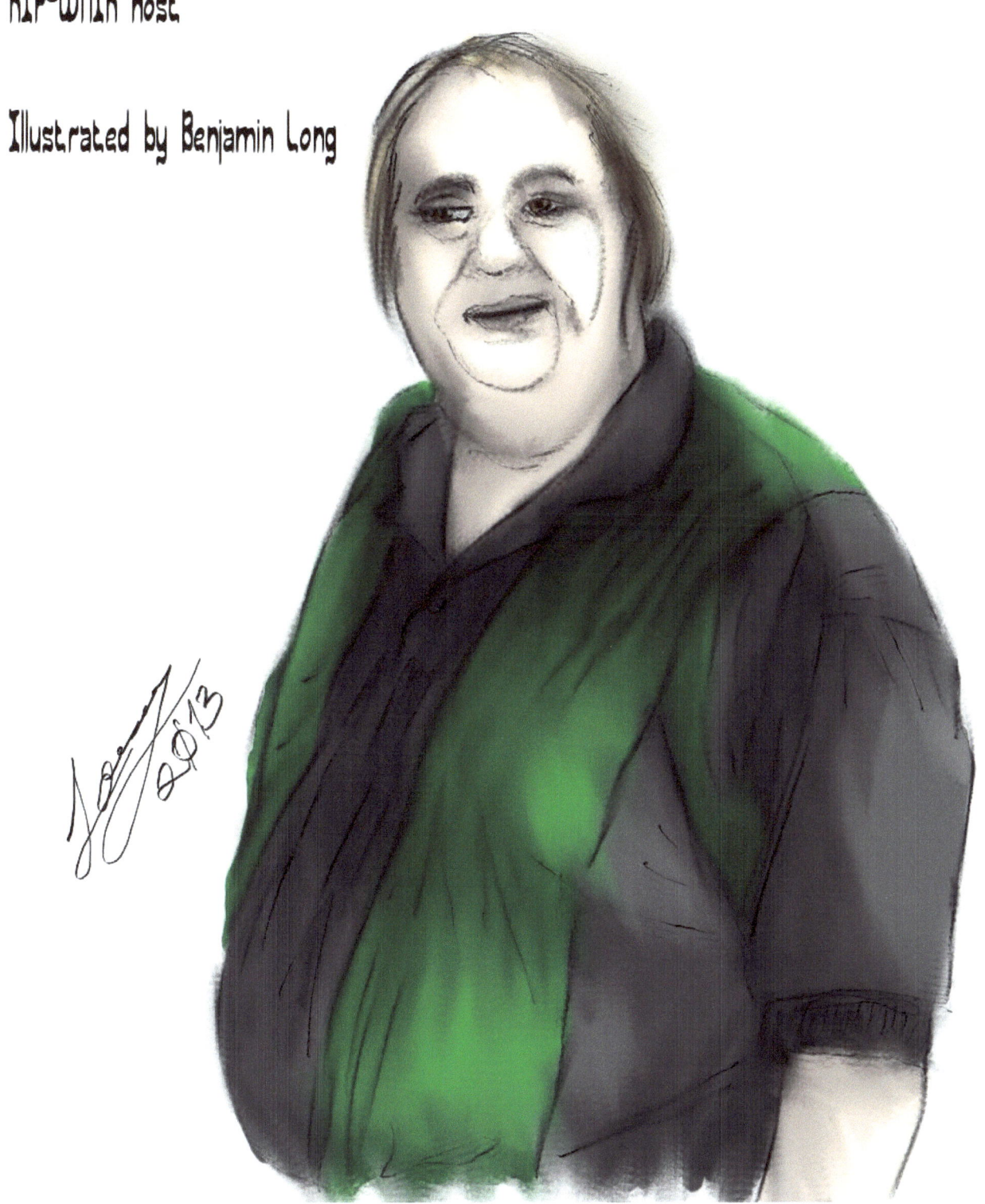

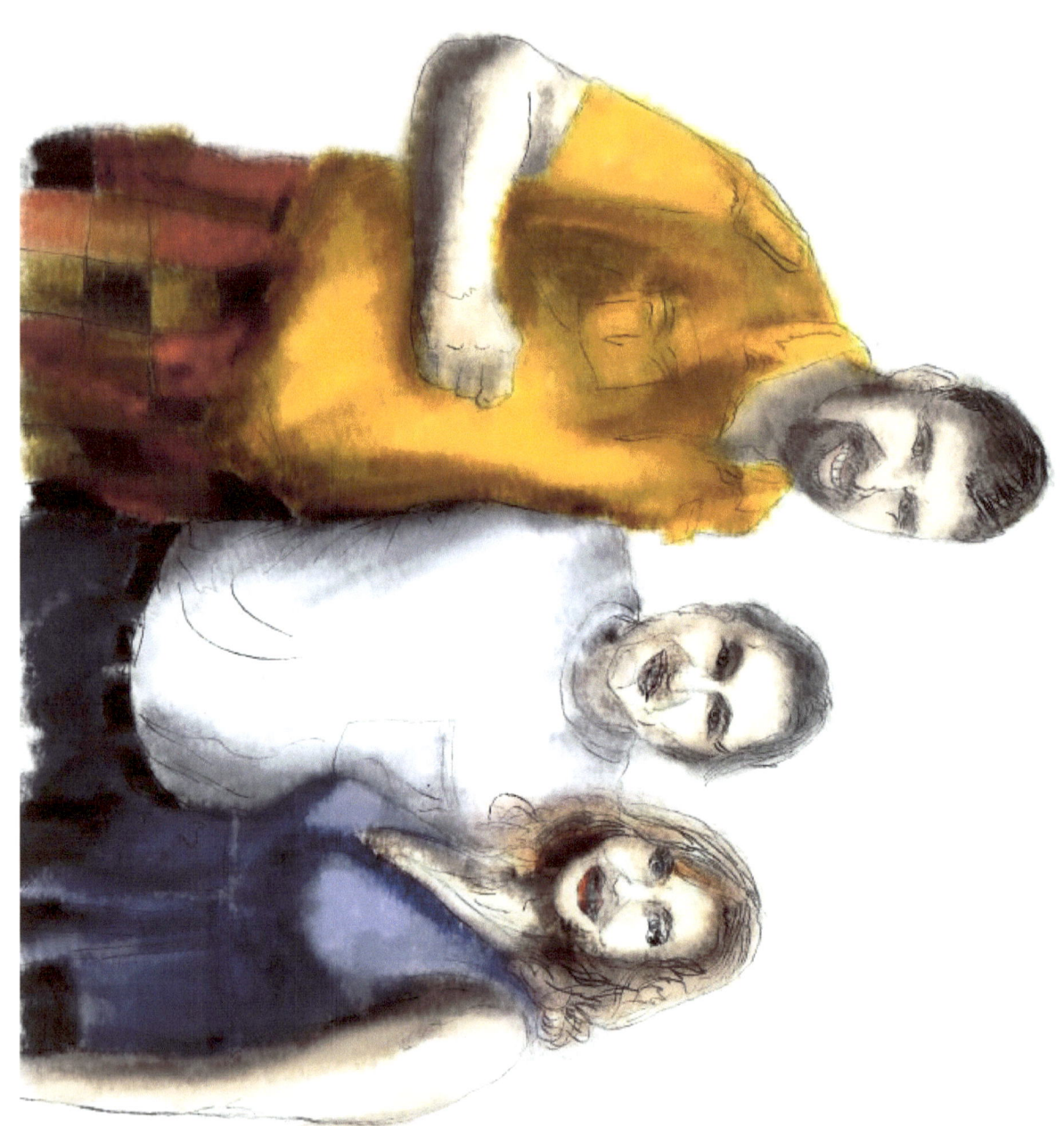

John Denning
Couch Burner Show WNIR

Illustrated by Benjamin Long

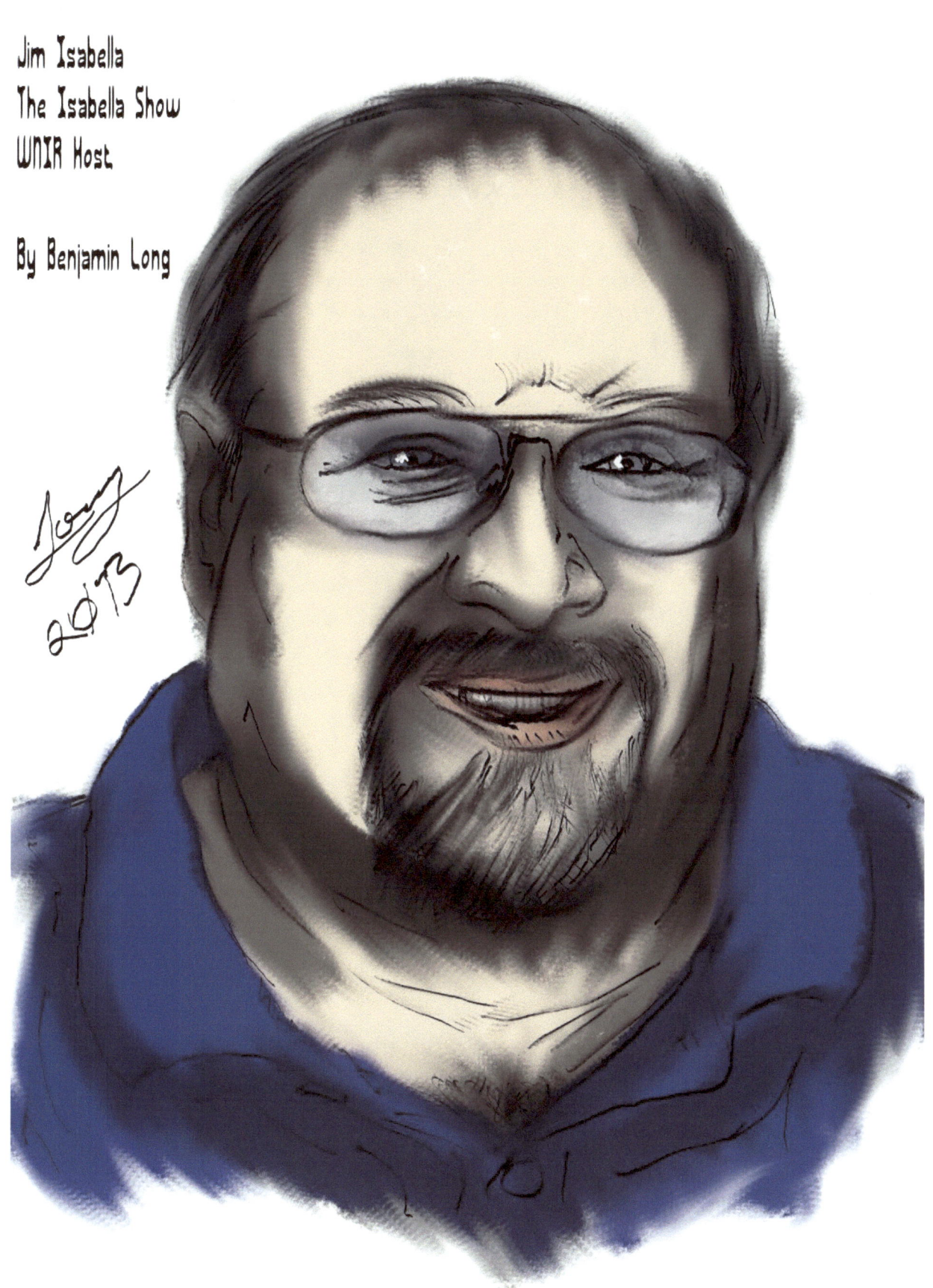

Maggie Fuller
WNIR - Morning Show
Illustrated by Benjamin Long

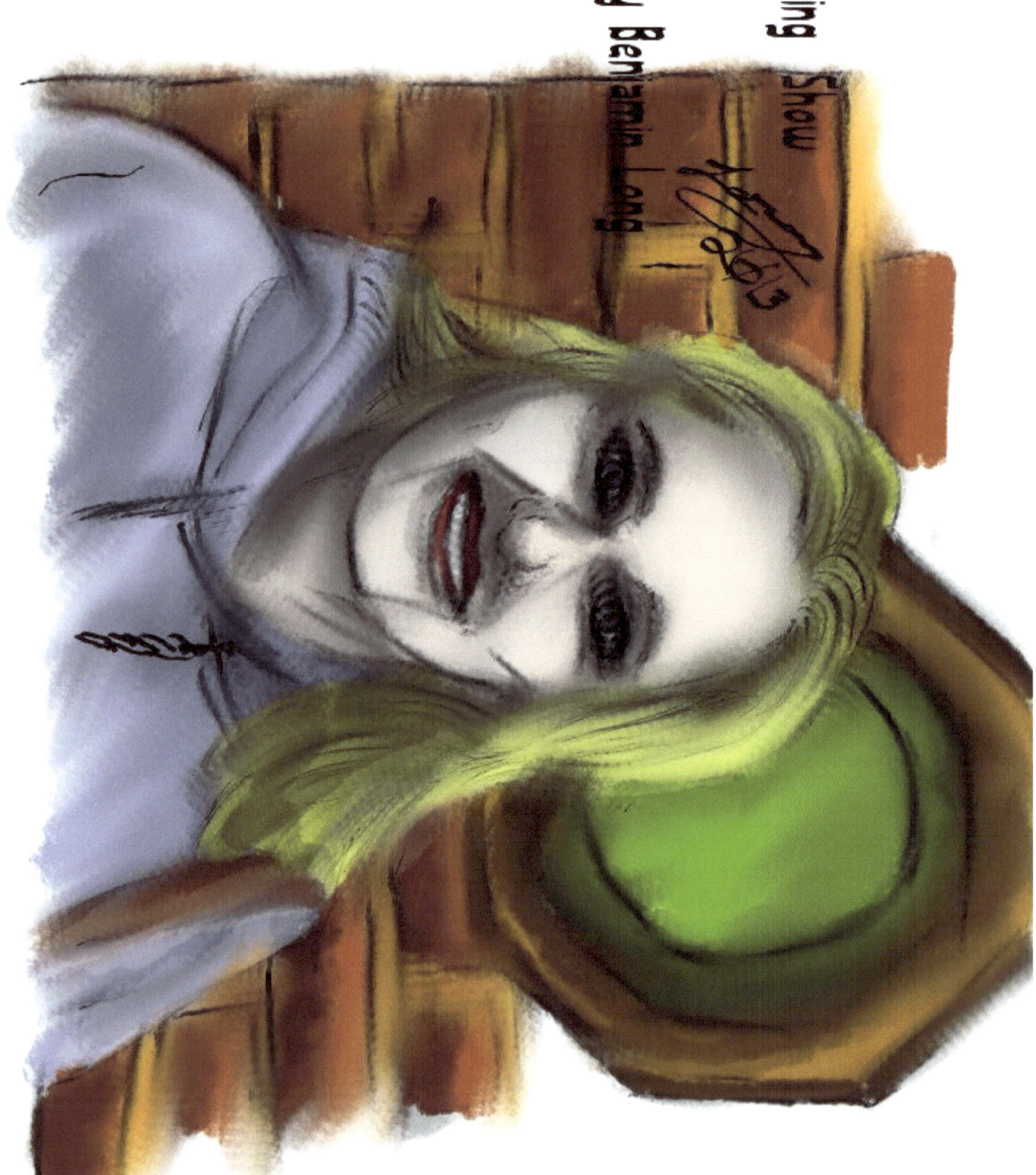

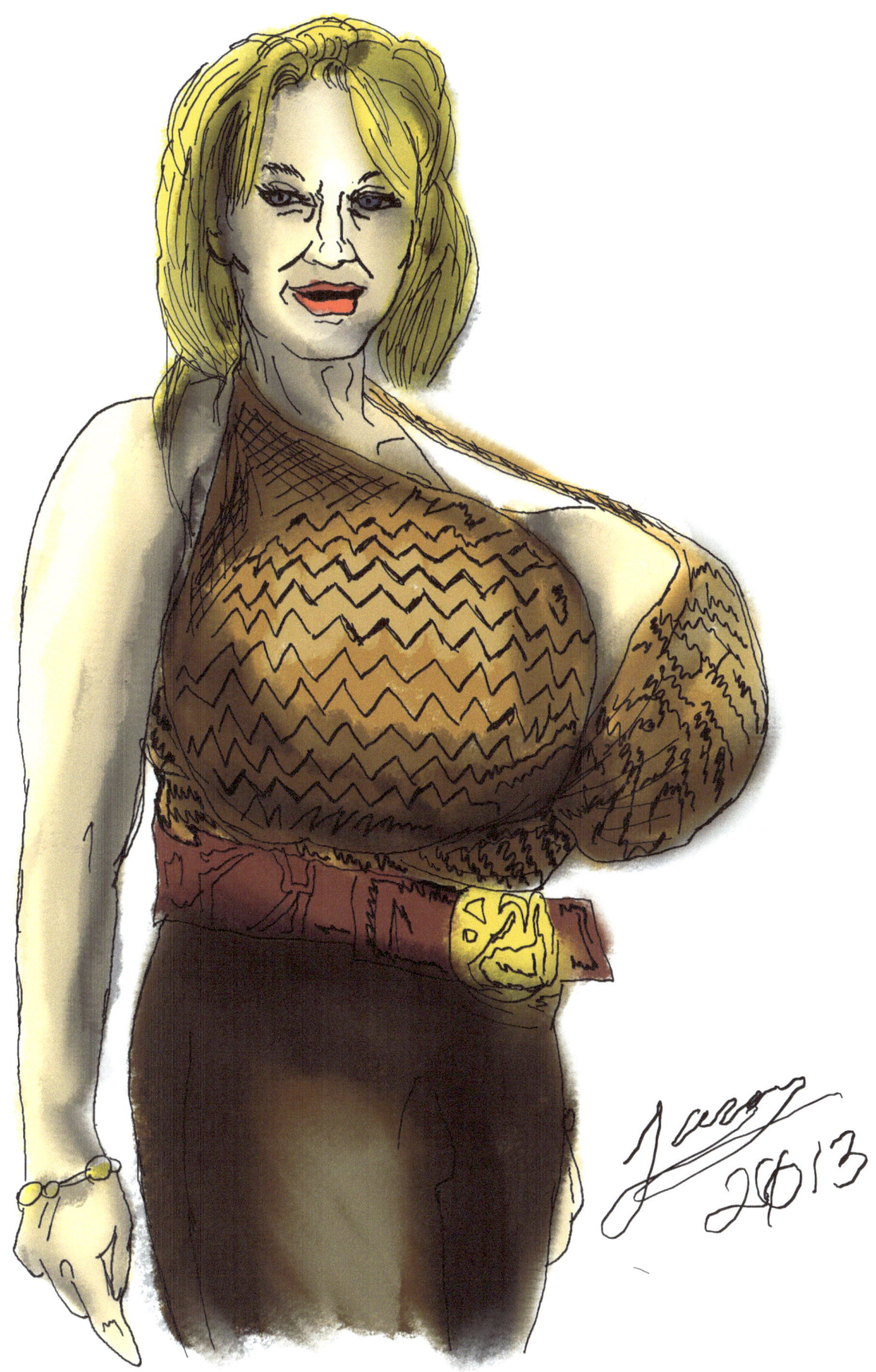

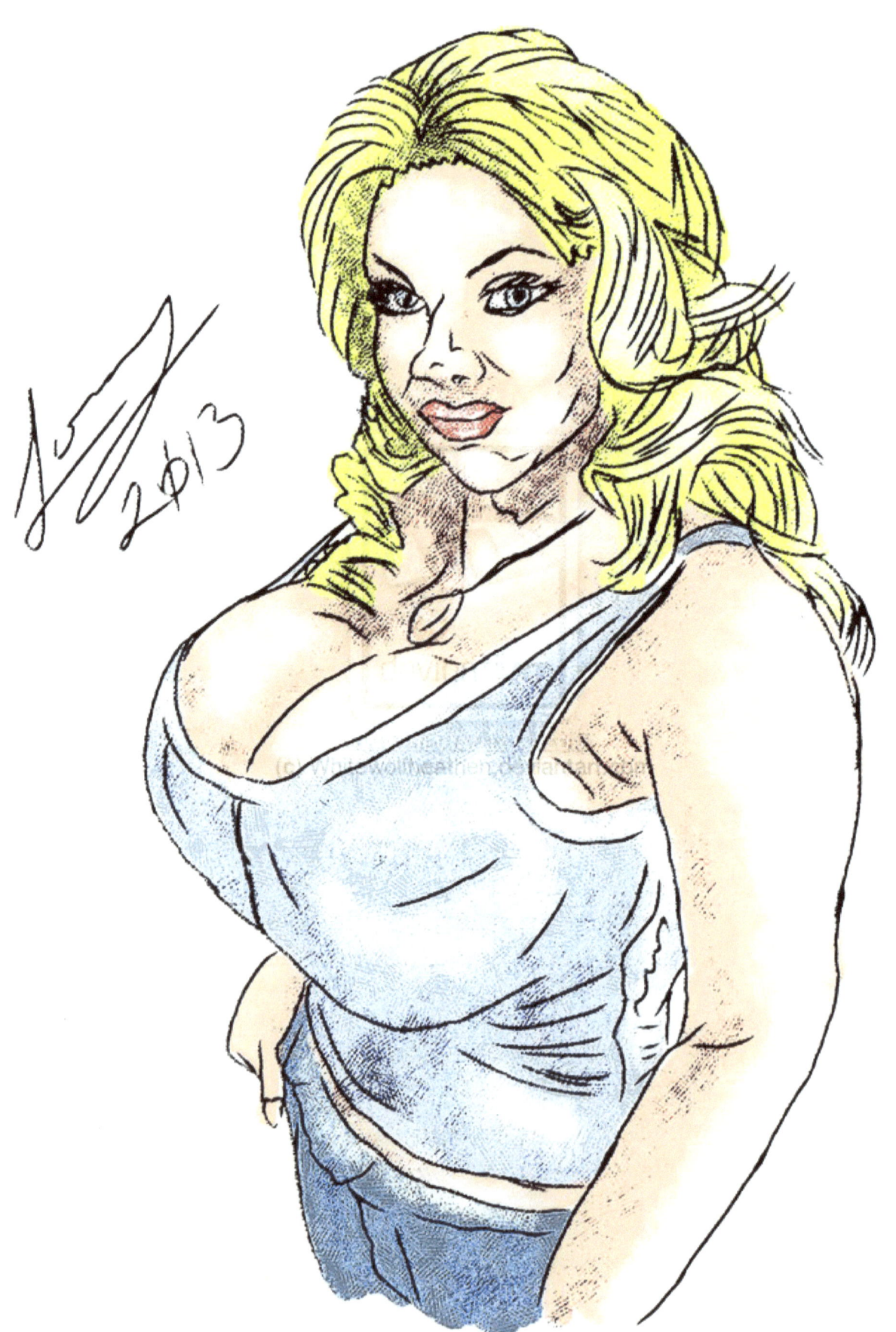

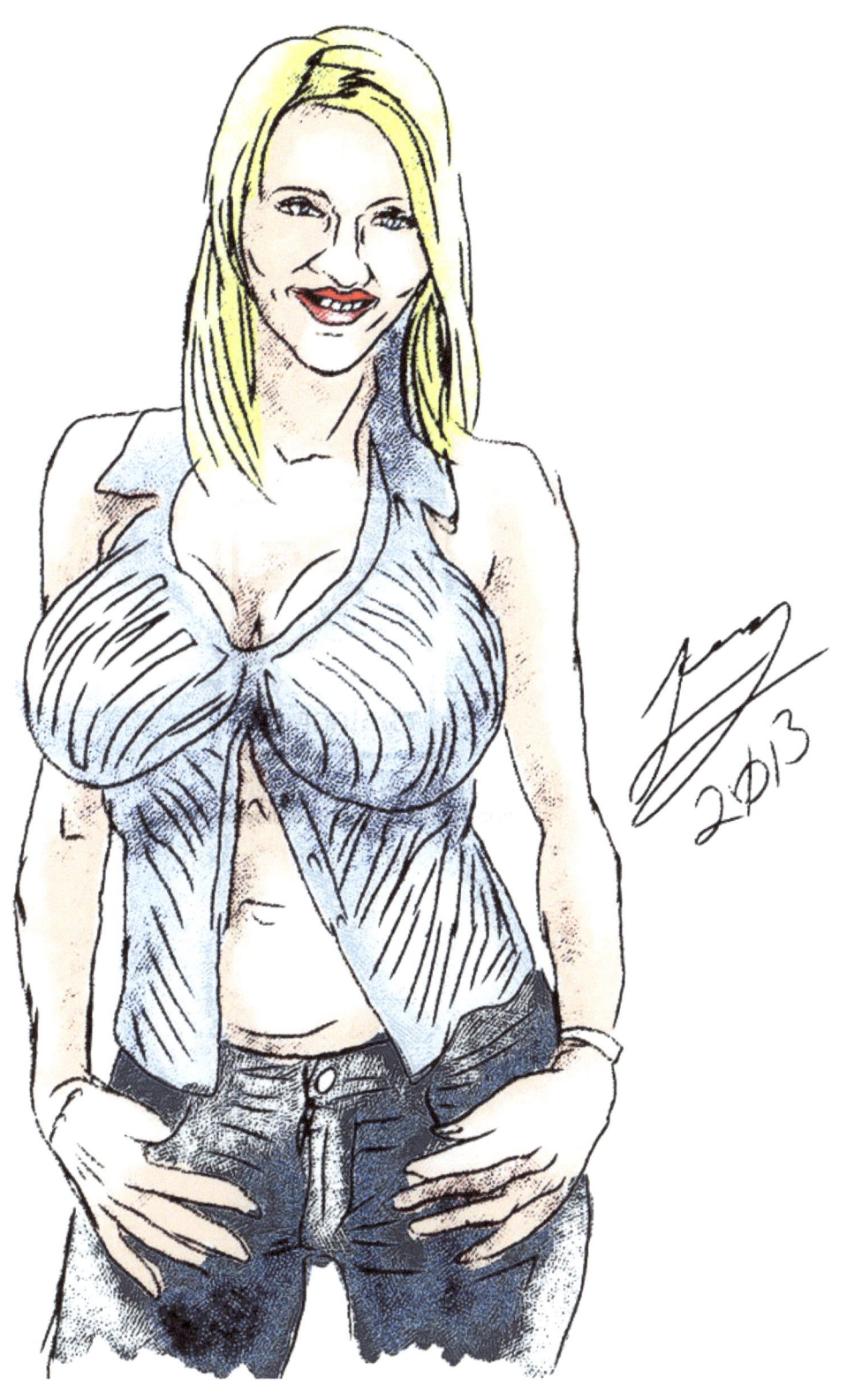

# Art by Benjamin Long

Art is protected by US Copyright law, all celebrity or movie images or celebrities or public figures are satire or parody under fair use clause.. Permission must be obtained to use any artwork unless it is under fair use guidelines.

Point of Contact:

Skype: whitewolfheathen

E-Mail: wiking88142001@yahoo.com

Thank you for enjoying this portfolio...

www.ingramcontent.com/pod-product-compliance
Lightning Source LLC
Chambersburg PA
CBHW050355180526
45159CB00005B/2023